DRAW AWESOME ALIENS AND RAD ROBOTS

WiTH NUMBERS AND LETTERS

Created by **STEVE HARPSTER**

www.harptoons.com

www.harptoons.com

Harpster, Steve
Draw Awesome Aliens and Rad Robots / written and illustrated by Steve Harpster

SUMMARY: Learn how to draw aliens and robots starting with numbers and letters
ART / General, JUVENILE FICTION / General

ISBN 13: 978-0-9960197-8-1
ISBN 10: 0-9960197-8-2
SAN: 859-6921

**This book is dedicated to my awesome
and rad boys Tyler and Cooper.**

Follow Harptoons on:

**For school visit information
www.harptoons.com or
contact Steve Harpster at
steve@harptoons.com**

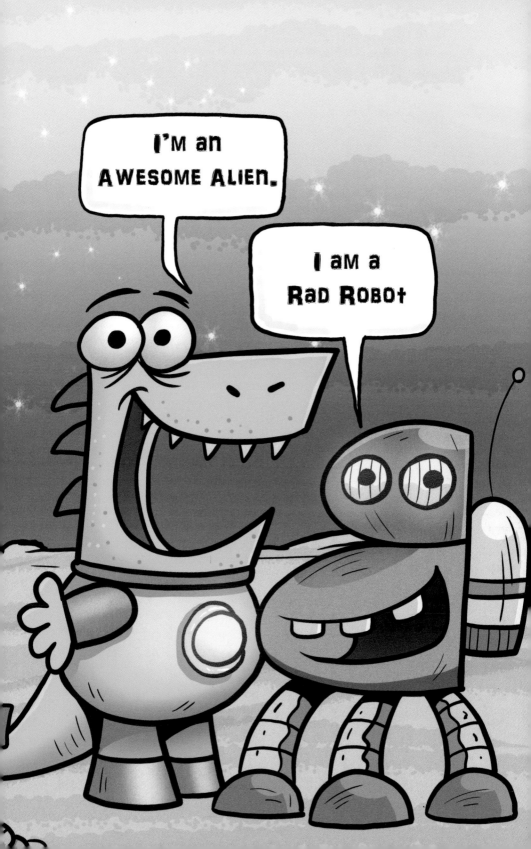

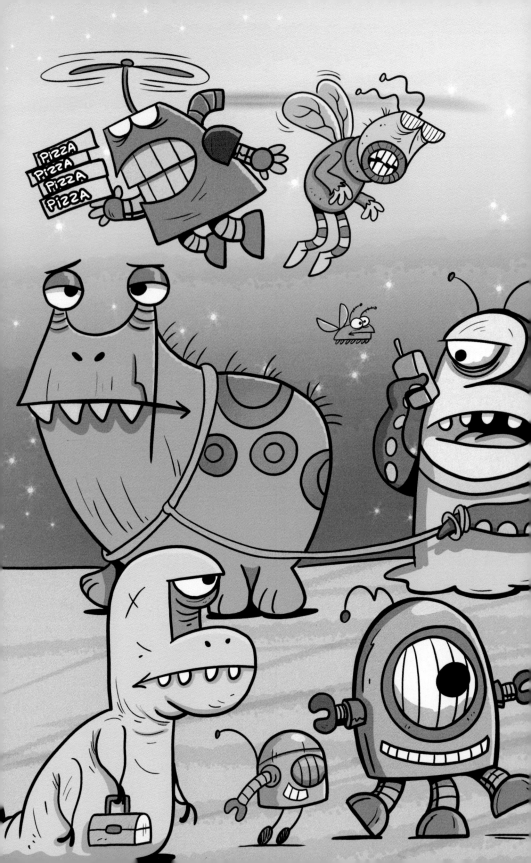

And this is our world. Have fun drawing all these fun characters. Try making up some of your own awesom aliens and rad robots.

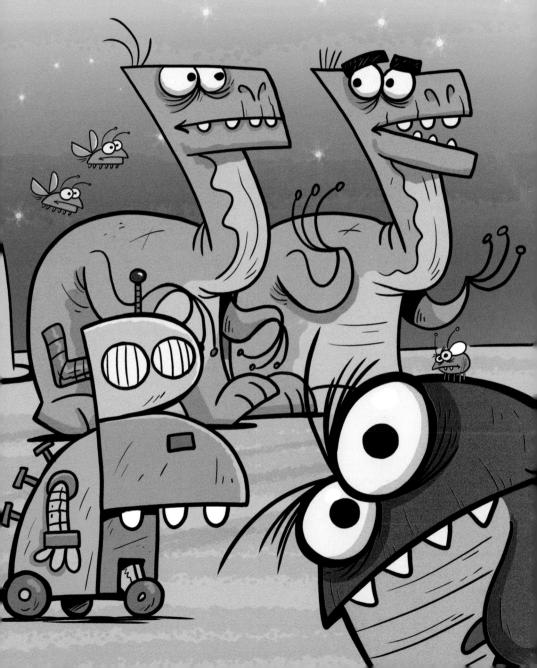

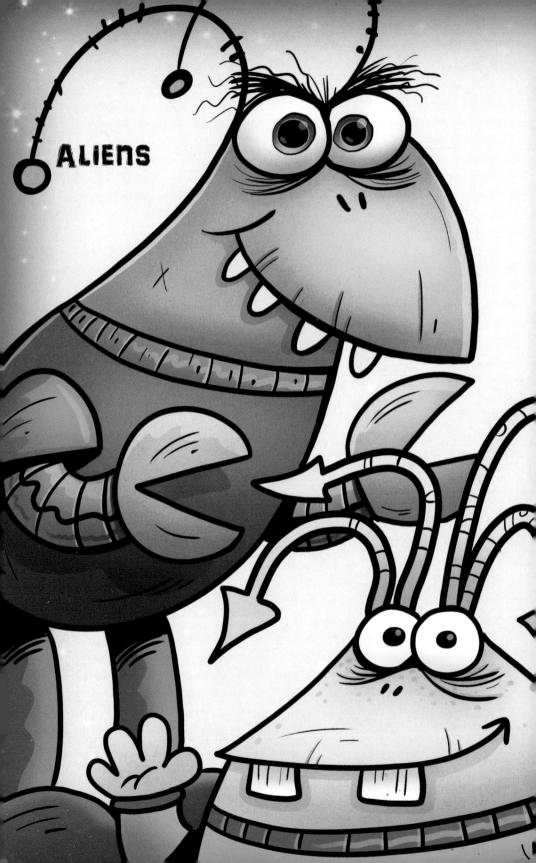

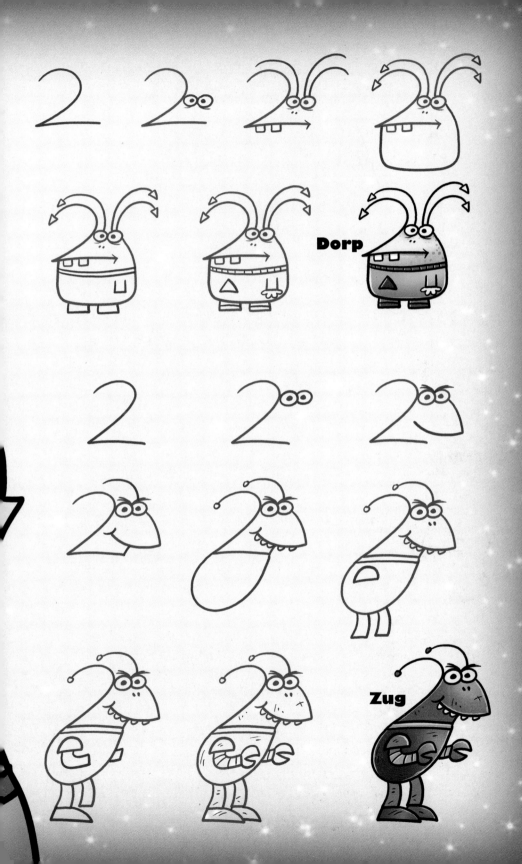

Dorp

Zug

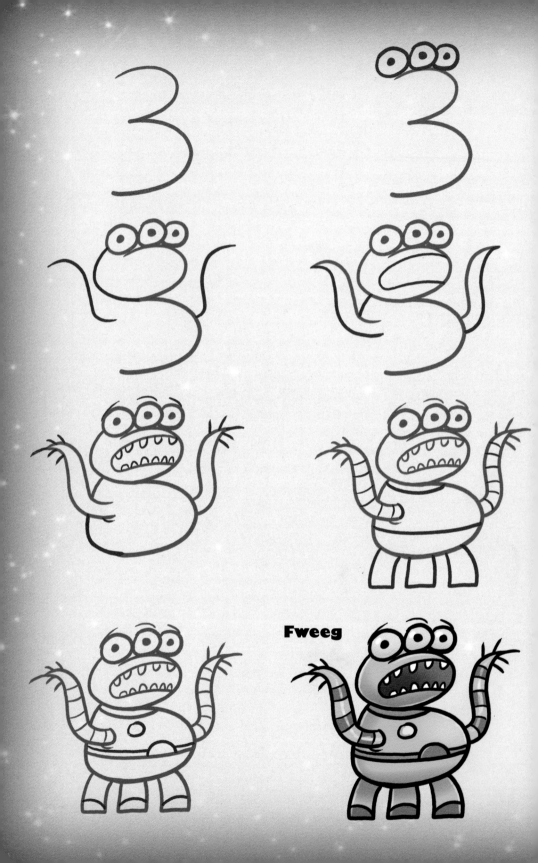

Fweeg

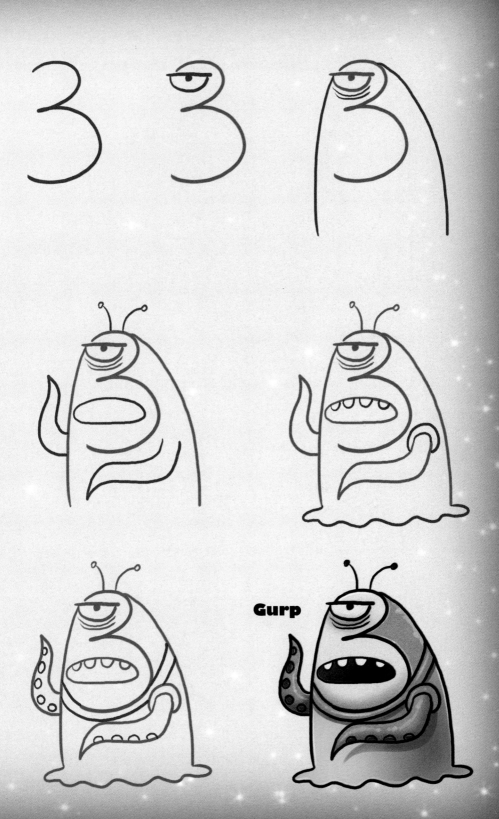

Gurp

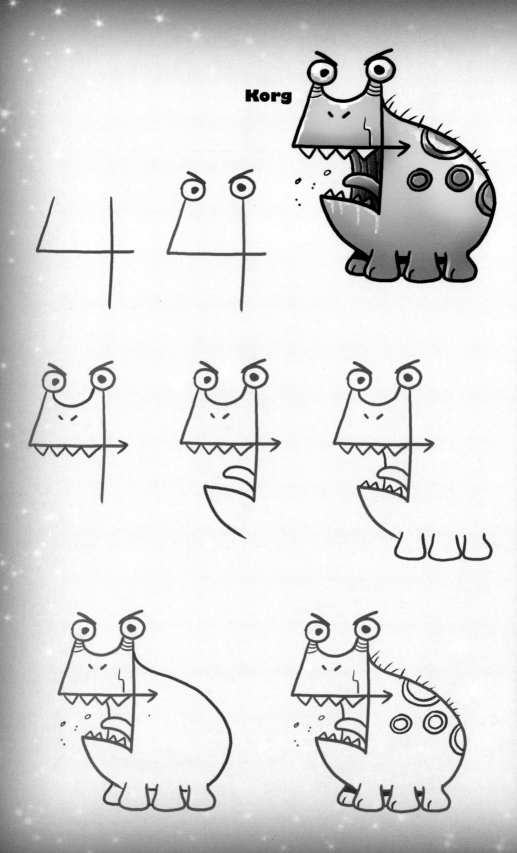

Korg

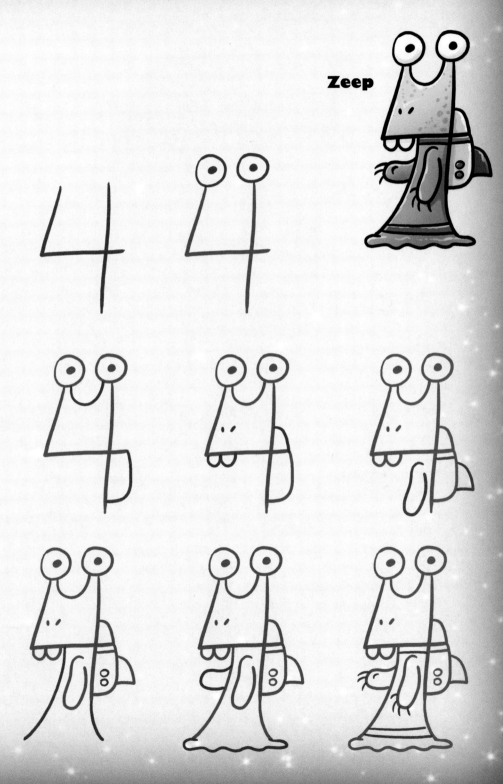

Zeep

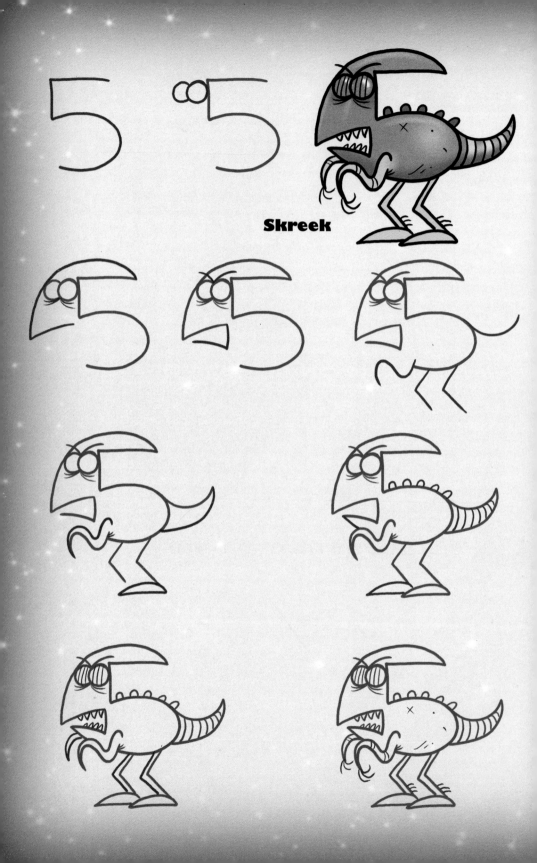

Skreek

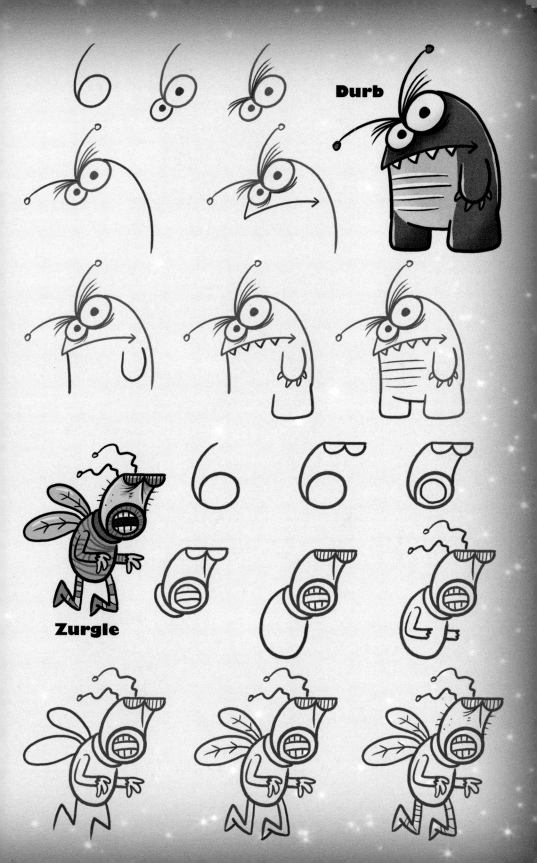

Durb

Zurgle

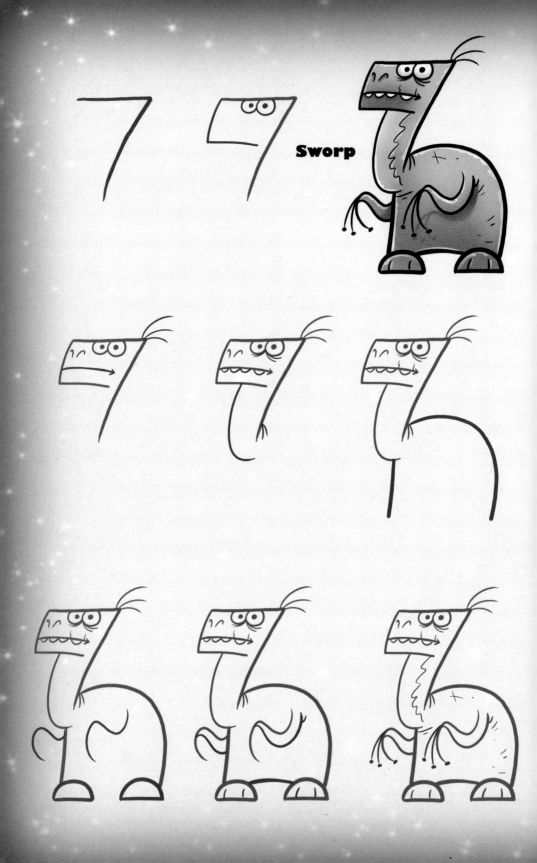

Sworp

Vormulac

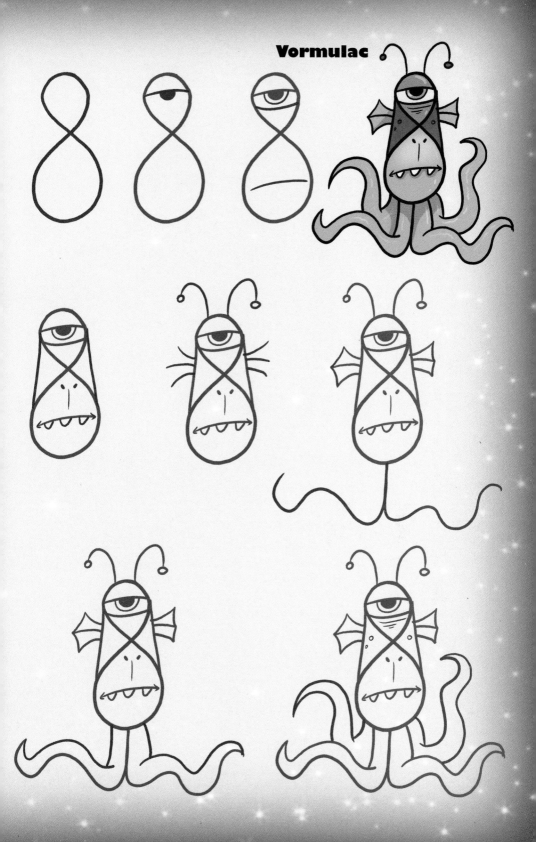

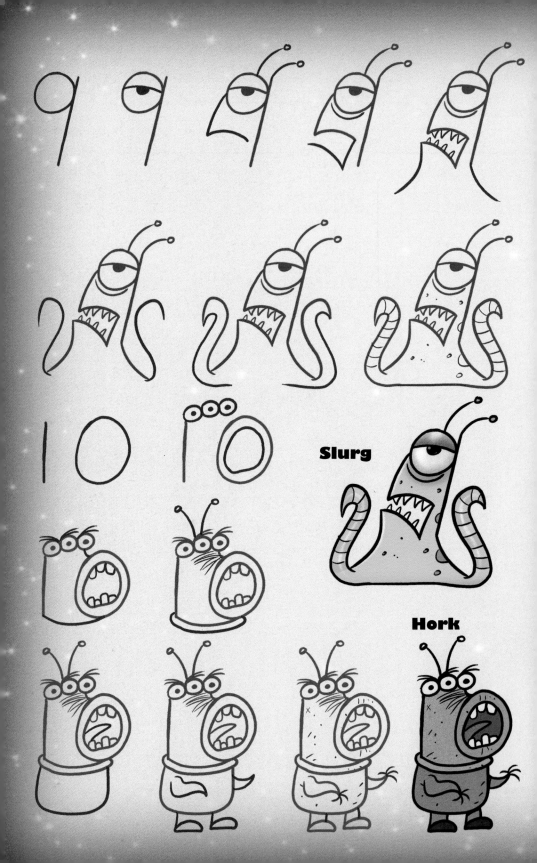

Slurg

Hork

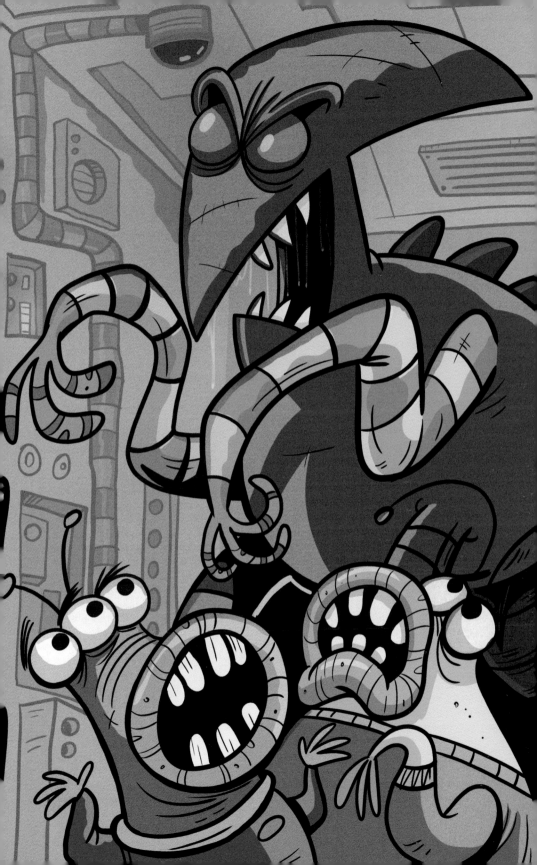

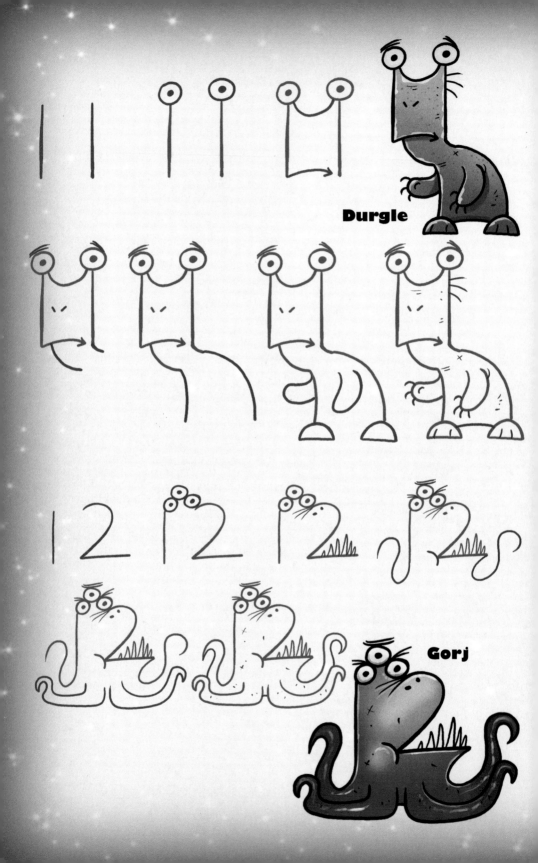

Durgle

Gorj

Zamulak

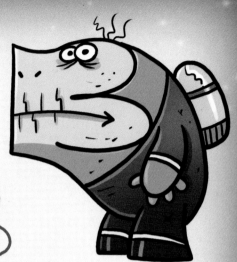

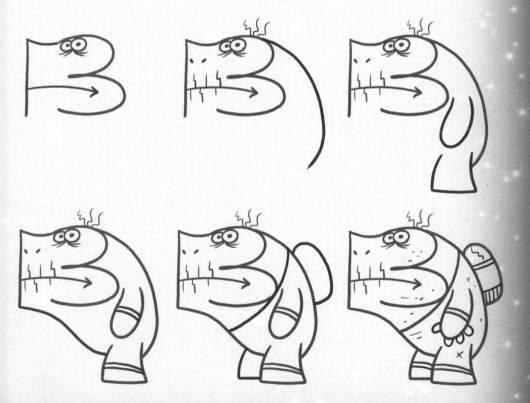

Ramzor

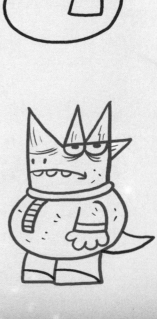

Furp

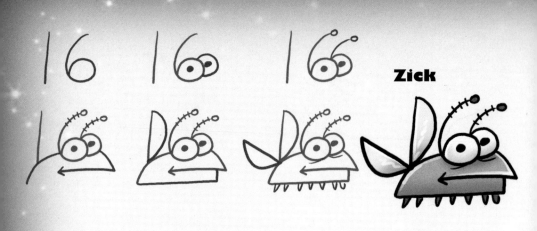

Zick

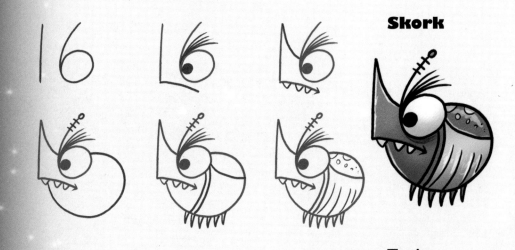

Skork

Twip

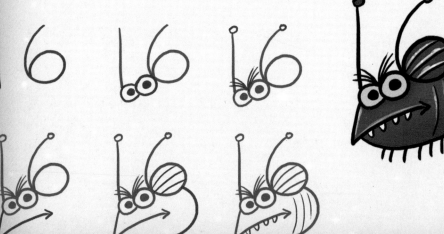

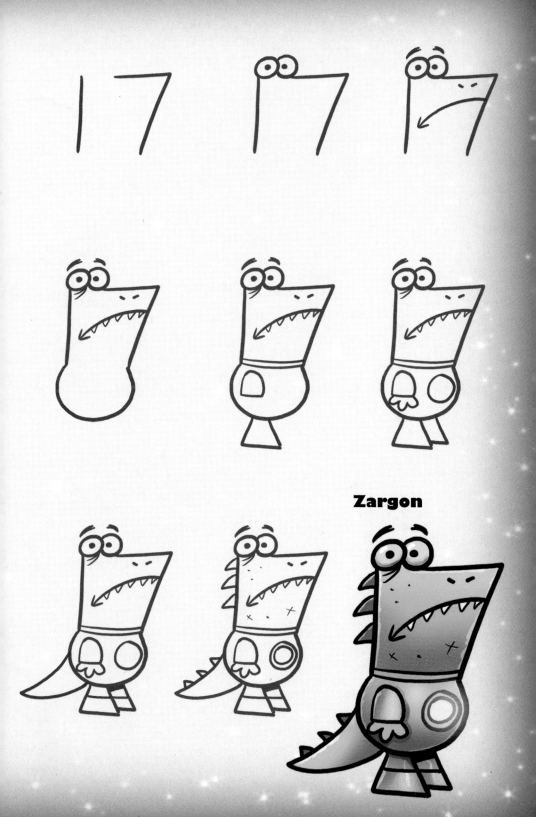

Zargon

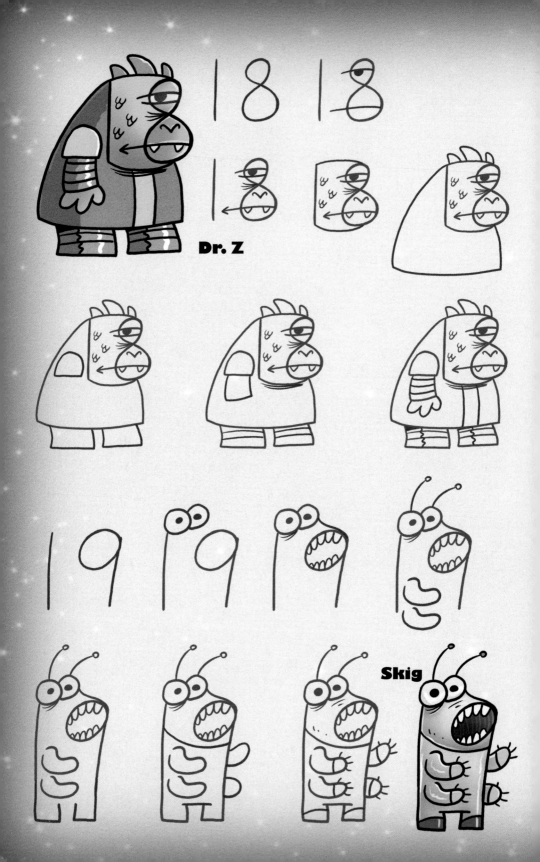

Dr. Z

Skig

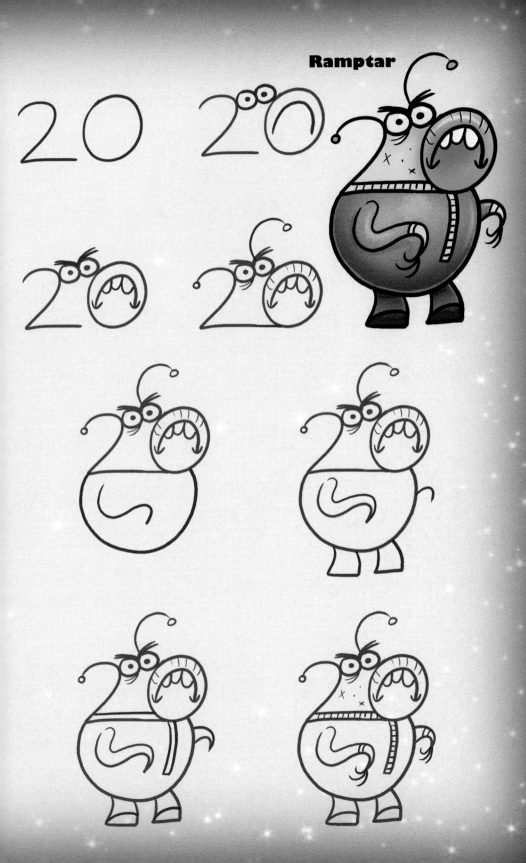

Ramptar

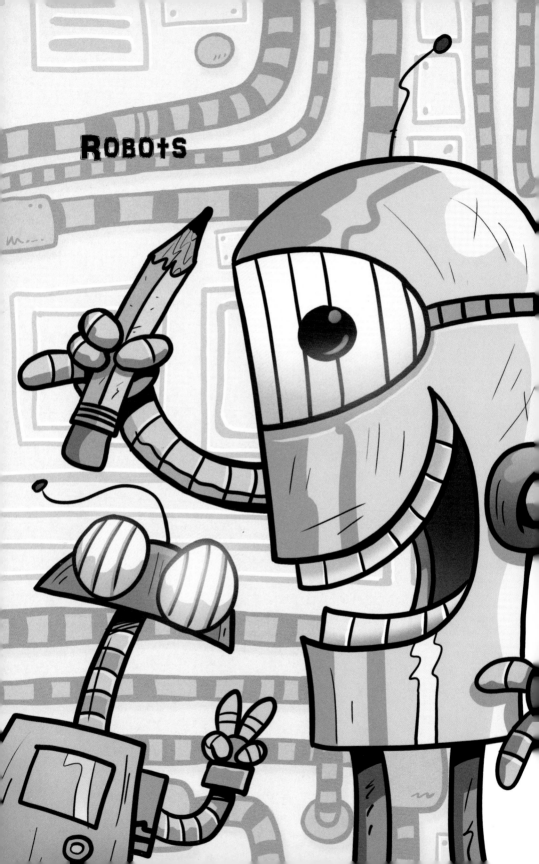

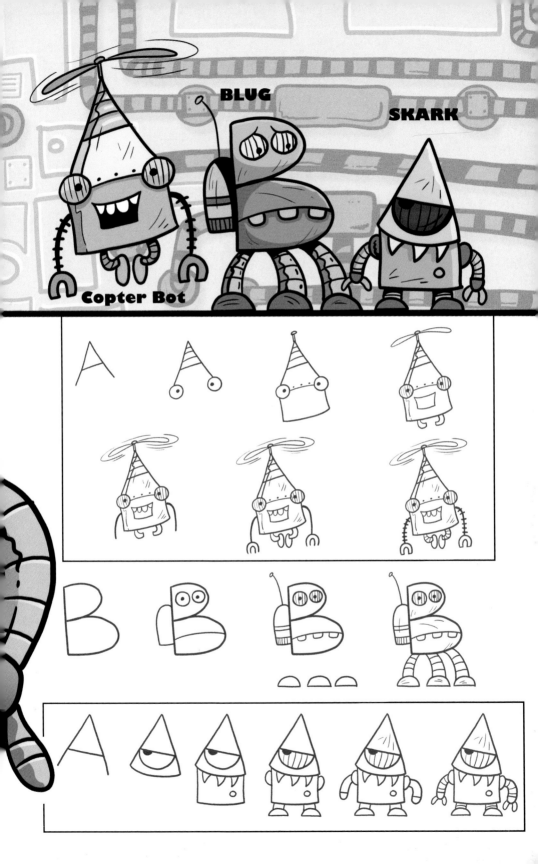

BLUG

SKARK

Copter Bot

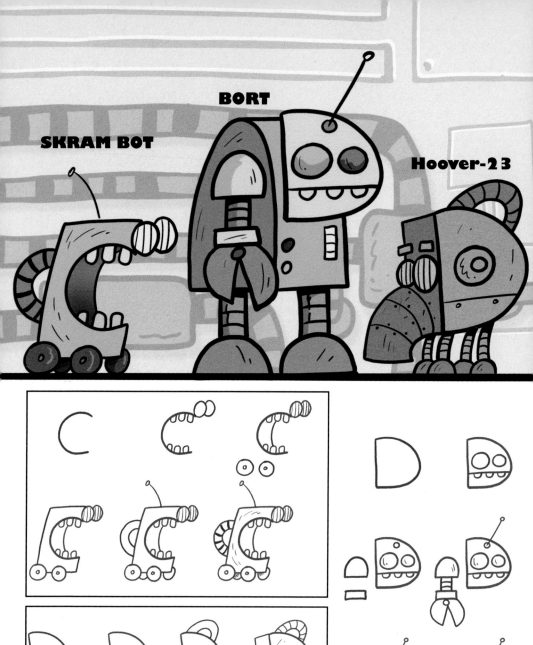

SKRAM BOT

BORT

Hoover-23

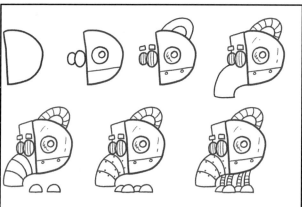

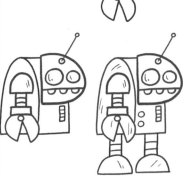

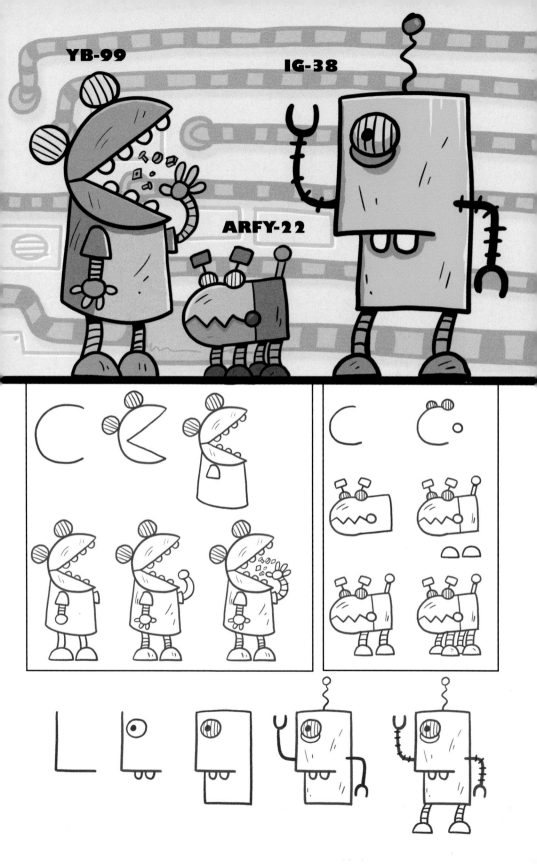

YB-99

IG-38

ARFY-22

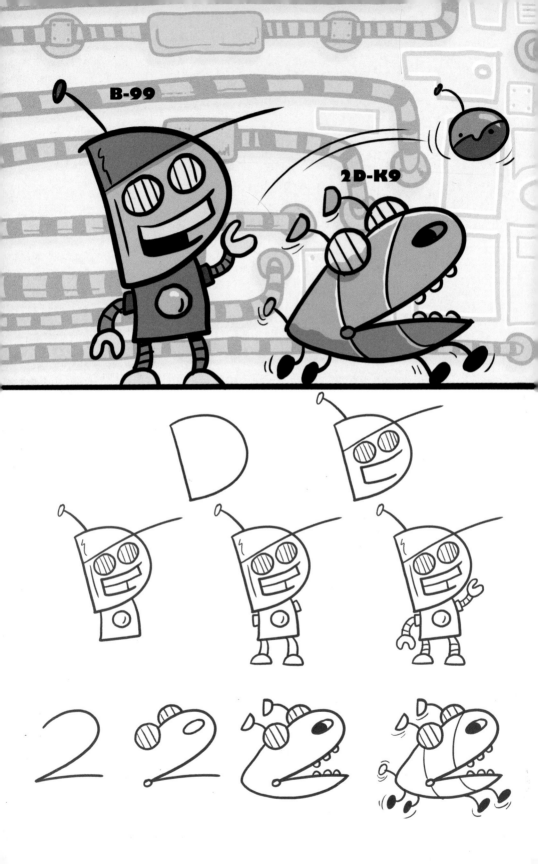

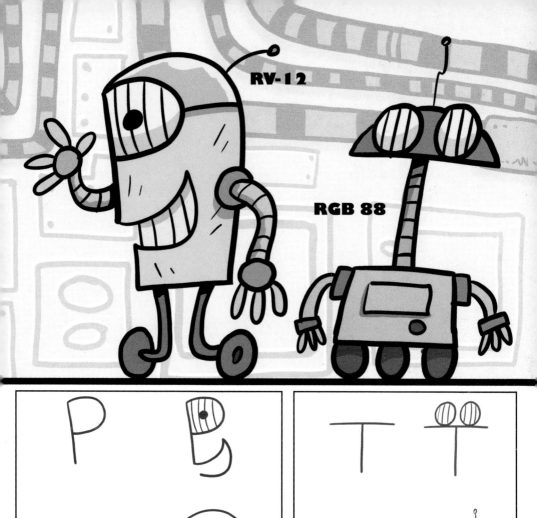

RV-12

RGB 88

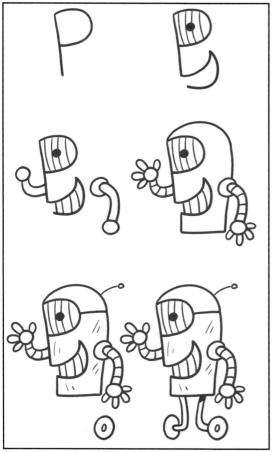

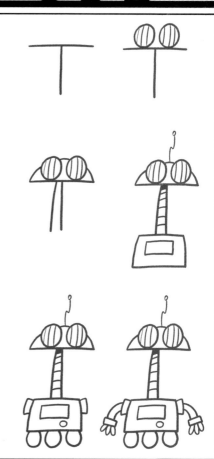

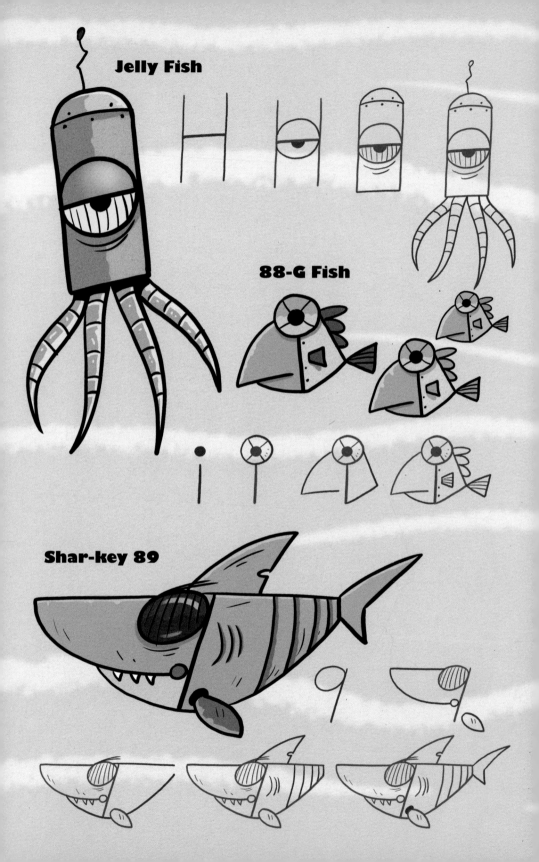

Jelly Fish

88-G Fish

Shar-key 89

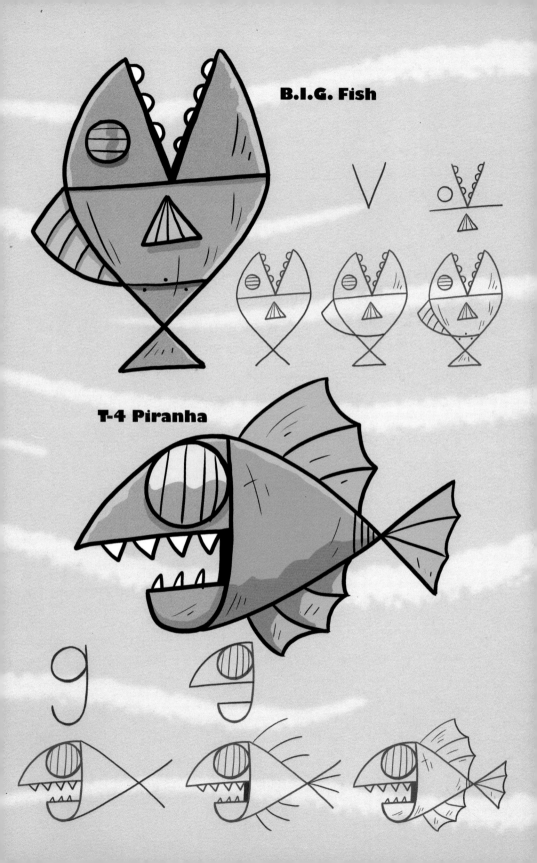

B.I.G. Fish

T-4 Piranha

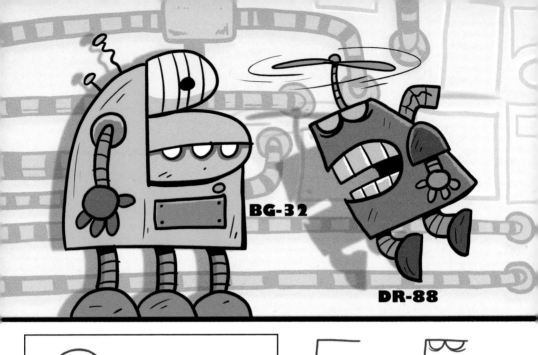

BG-32

DR-88

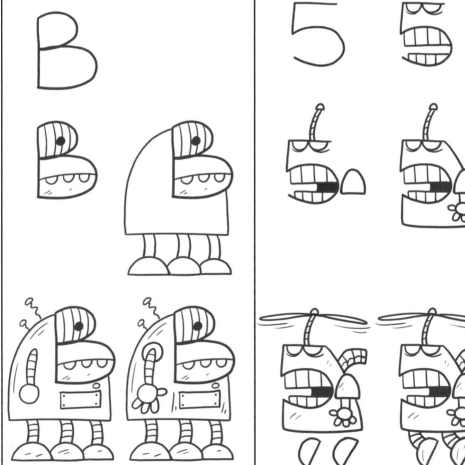

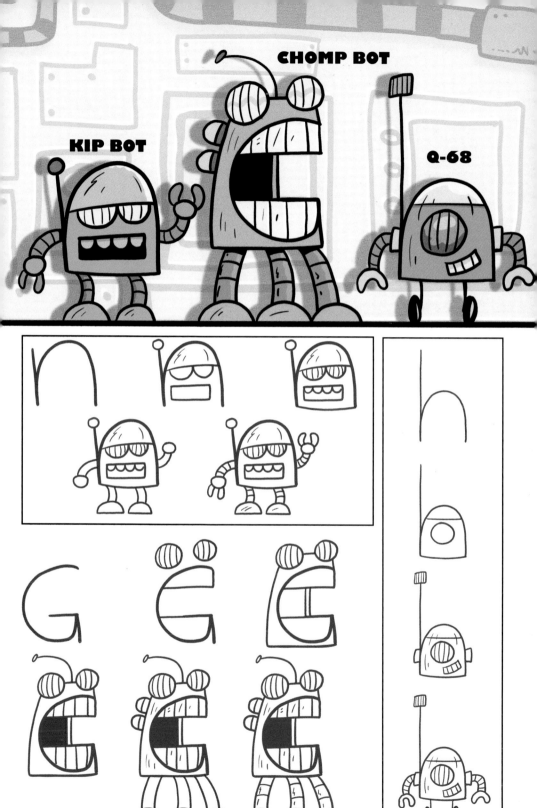

KIP BOT

CHOMP BOT

Q-68

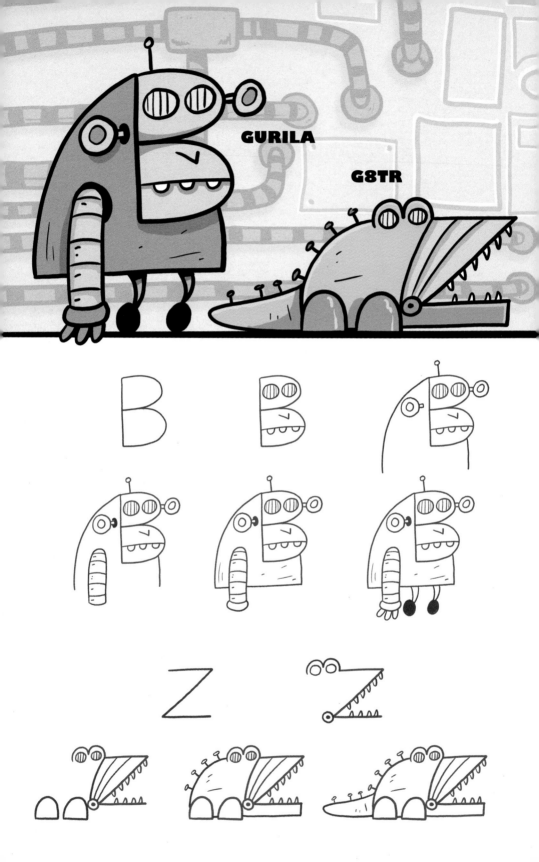

GURILA

G8TR

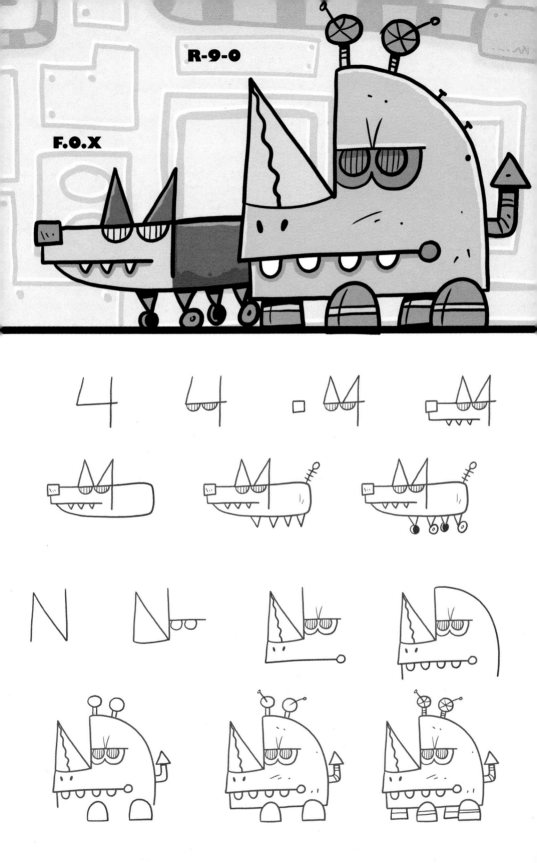

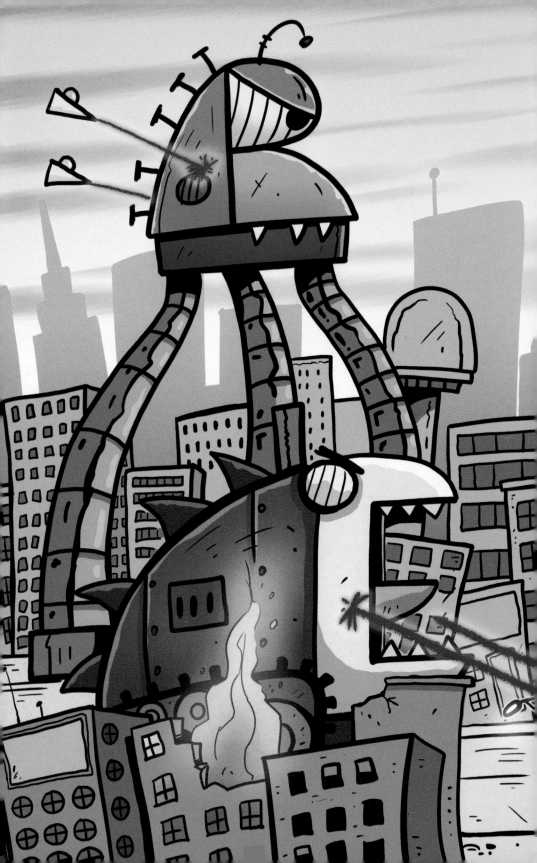

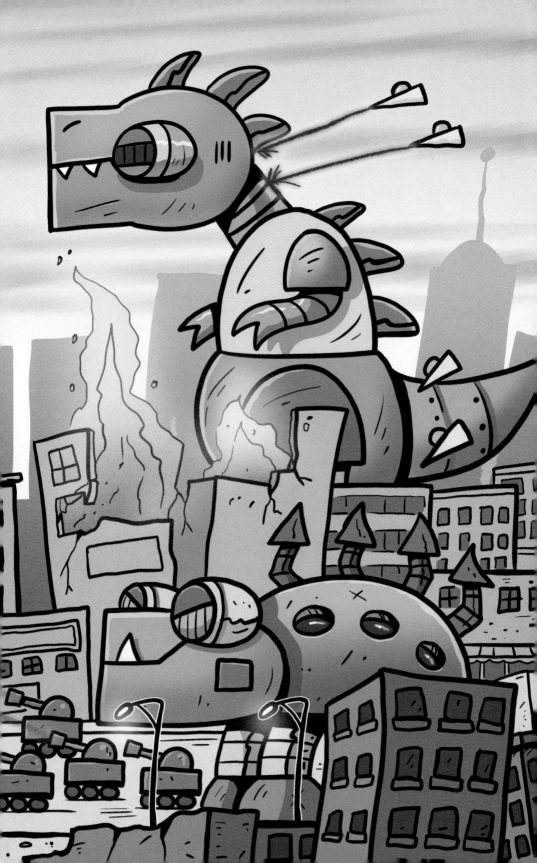

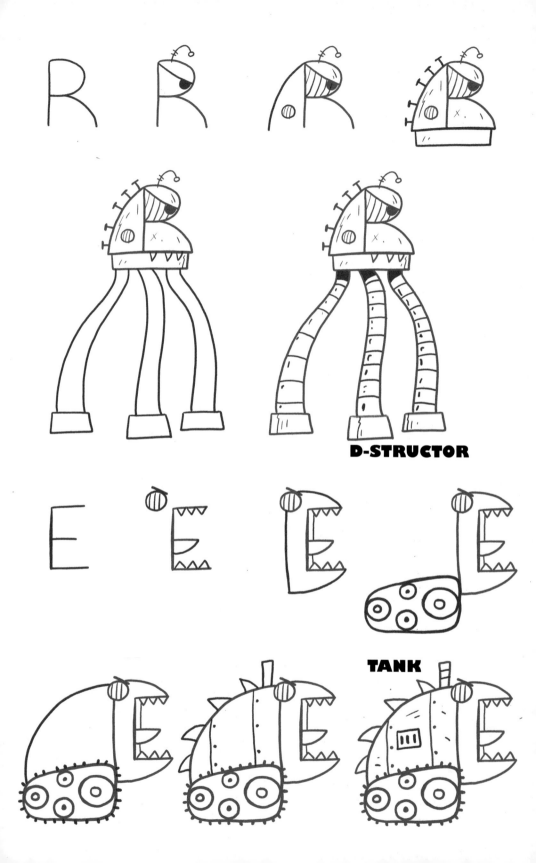

D-STRUCTOR

TANK

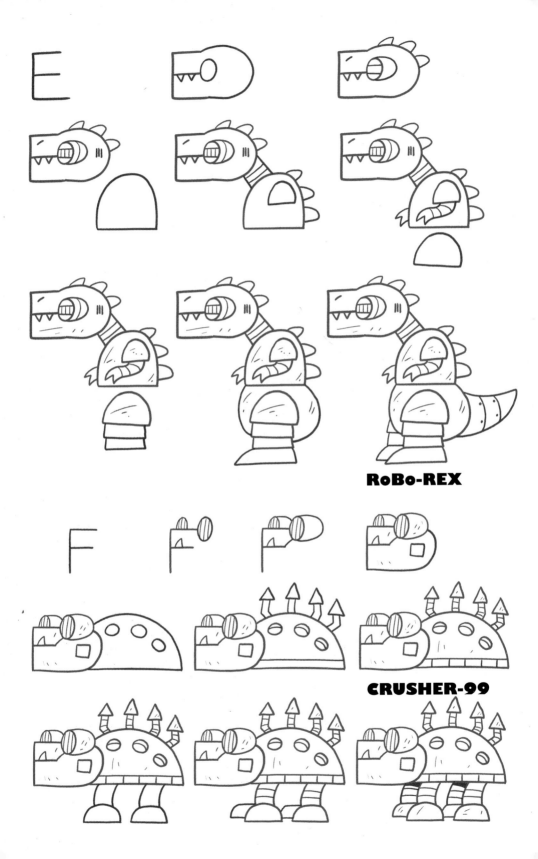

RoBo-REX

CRUSHER-99

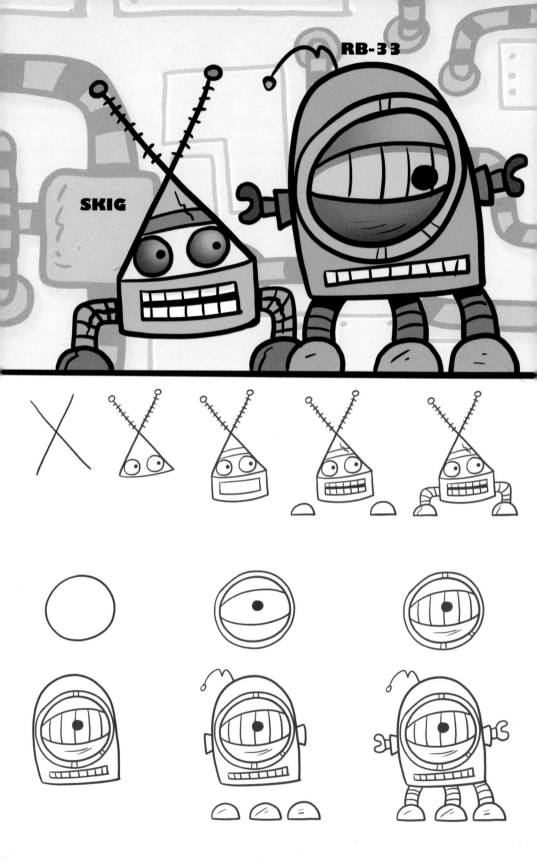

SKIG

RB-33

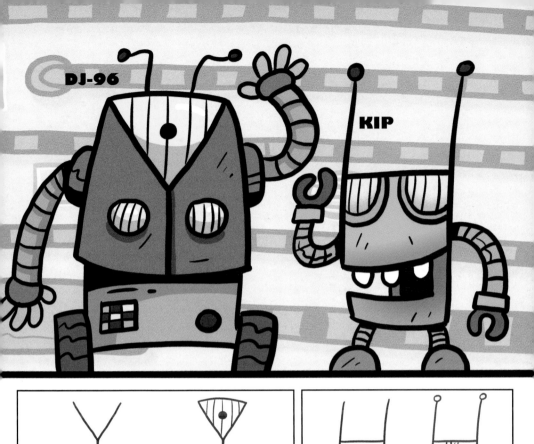

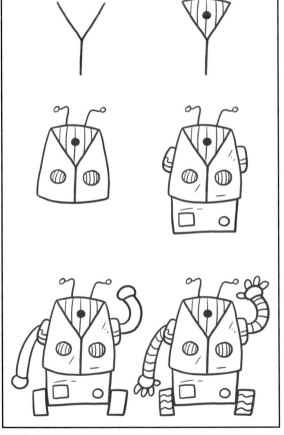

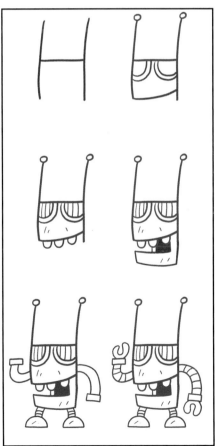

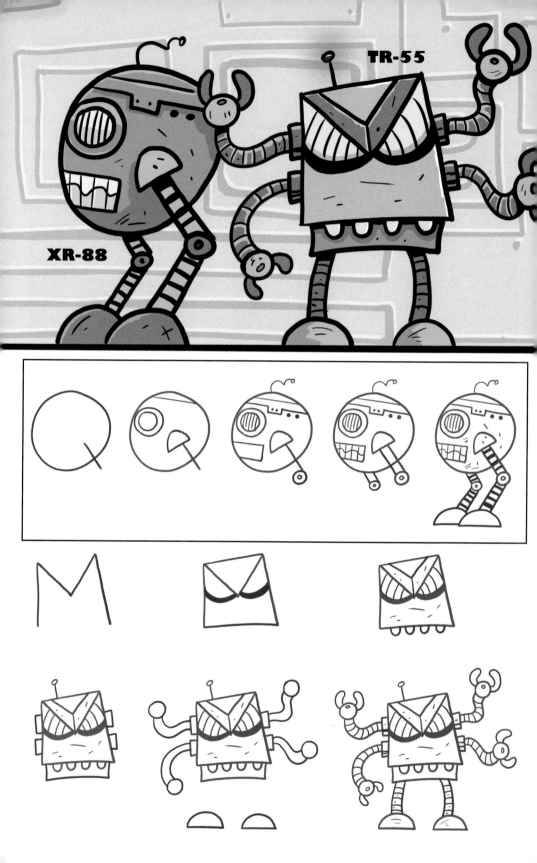

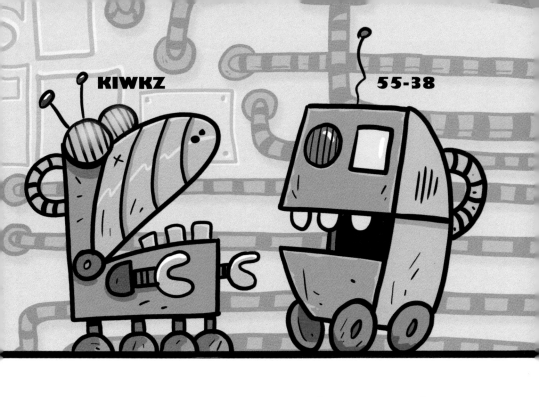

KIWKZ

55-38

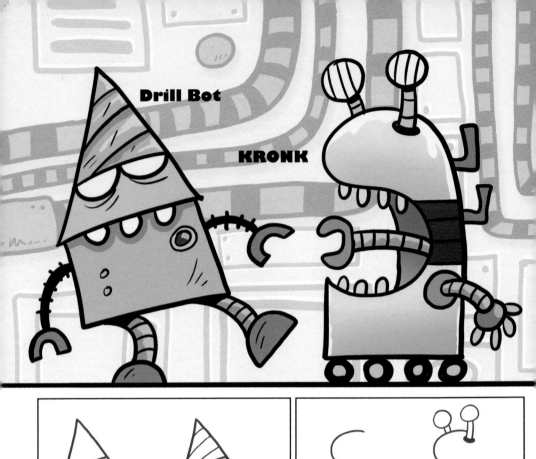

Drill Bot

KRONK

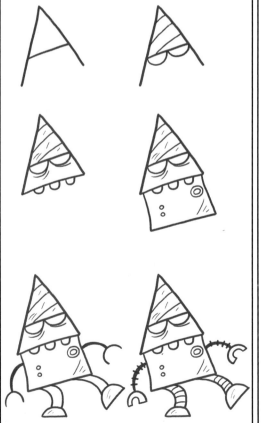

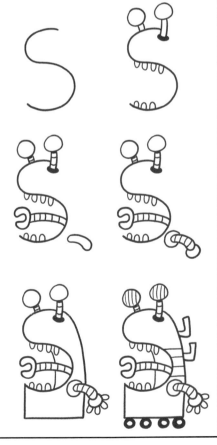

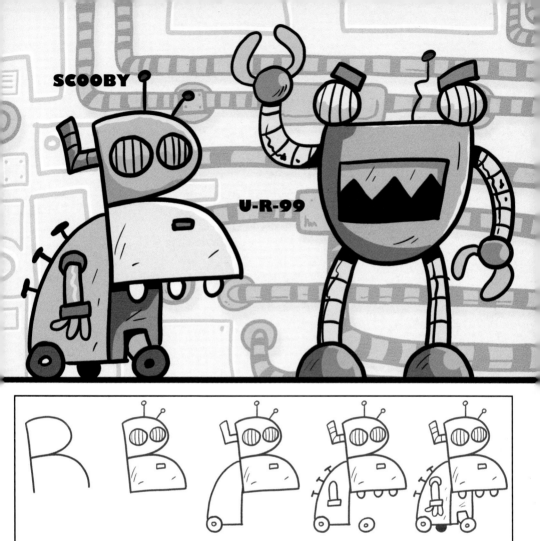

SCOOBY

U-R-99

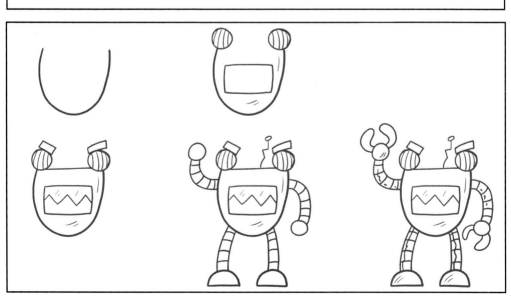

Visit Harptoons.com and watch how-to-draw videos, print off FREE coloring and activity pages, and create fun crafts. Mail your drawings to Harptoons.com and you might see it in featured in the Art Show. All this and more at the greatest drawing site dedicated to getting young people drawing, creating and imagining.

Follow Harptoons on: